WHAT PEOPLE ARE SAYING
ABOUT WYLAND . . .

"Wyland is a marine Michelangelo."

"Wyland is considered by many to be the finest environmental artist in the world."
The Congressional Record, Vol. 139, No. 112 - Part II

"The United Nations proclaims Wyland the official artist for the International Year of the Ocean, 1998."

United Nations

". . . I share your commitment to protecting the environment for future generations."
Bill Clinton, President of the United States

"Your organization is making an invaluable contribution to the effort to promote environmental awareness among our youth and to encourage them to continue their own efforts . . . Please accept my congratulations on your success and my best wishes for the future."
Al Gore, Vice President of the United States

"Your larger-than-life murals across the country have heightened the awareness of our precious ocean resources. I share your enthusiasm with respect to the powerful educational tool an ocean mural challenge can be to our students."
Daniel K. Inouye, United States Senator

"It is always a treat to see what you have been up to, and it's even more fun to see you've been up to something Disney!"
Michael D. Eisner, Chairman and CEO, The Walt Disney Company

"Maritime Michelangelo"

Boston Sunday Globe

"Whales and Wyland, Wyland and whales. They fit together in a wonderful relationship. Wyland has dedicated his life and his art to the whales, and the whales in turn have received great benefit from Wyland's life and talent."
Robert Bateman, Wildlife Artist

"On behalf of the United Nations Environment Programme I would like to congratulate you on your very timely efforts toward preserving the oceans of the planet. I would also like to extend my sincere compliments to you on your extremely beautiful and ambitious work."
Joanne Fox-Przeworski, Director, Regional Office for North America,
United Nations Environment Programme

"Like no one else, Wyland captures that unique blend of undersea fantasy and natural fact with a beauty and grace that sets him apart. Like the whales he paints, Wyland is a huge presence in the world of marine life art."

Chris Newbert, Marine Life Photographer

"I salute you, Wyland, and I suspect that whales salute you, too. In my mind's eye, I see whales out there large and small, all spyhopping and craning their necks, trying to get glimpses of your work."

Dr. Roger Payne, Whale Biologist

"When I saw the beauty and shared the emotion of Wyland's art, my appreciation of the whale increased."

Lloyd Bridges, Actor

"I am writing in support of Wyland's Ocean Mural Challenge of America. . . . By inspiring young people to actively participate and celebrate 1998 as the International Year of the Ocean, we are teaching our young people to be environmentally responsible. In your own very appropriate words, 'If one kid grows up to be another Cousteau, (the) efforts will have been worthwhile.'"

Carl Levin, United States Senator

"Broad Strokes Revive Interest in Whales"

The New York Times

"Wyland is a big-picture can-do sort of guy who the moment he has a dream — such as helping every school in the United States paint a Wyland-style mural, or erecting sculptural fountains worldwide of manatees and manta rays at play, or replacing all his deteriorating murals with hand-painted tile art that will last thousands of years — looks for ways to make it happen."

Canada's National Newspaper, *The Globe and Mail*

"Prince of Whales; Muralist-to-the-Max Wyland is using his talents to help set the real Willy free."

People Weekly

"A Whale of a Task — The Inc. 500: The Fastest-Growing Private Companies, Wyland Studios"

Inc. Magazine

"A Whale of a Wall"

National Geographic World

"Planet Ocean, by the artist Wyland, is the largest mural in the world, measuring 105 feet high and 1,220 feet long (128,000 square feet). It is painted on the Long Beach Convention Center, California, and was completed on May 4, 1992."

The Guinness Book of Records 1995

"Imagine the excitement when I discovered immense life-size whales swirling and zipping about. What a tremendous imaginative undertaking, so in keeping with the environment, what great subject matter and how capably and beautifully this talented daring young artist has so boldly tied into this awesome task."

LeRoy Neiman, Artist

"As we work on the ocean day in and day out, trying to better understand the humpback whale and their critical needs, it is gratifying to know that there is someone out there who has captured the spirit of the whales, portrayed them at 'life size' so that all of us might share their magnificence, and work so diligently at educating 'man-kind' to the wonder of life we share with all living things."

Mark and Debbie Ferrari, Marine Biologists

"I had already realized that research and science is great and important, but the challenge today is to make people care; affect public attitudes so voters in turn can affect government policy . . . Wyland's whales, large and powerful enough to demand public attention, were a sign to me that someone else felt the same way. Here was a monument as large as a building that had feeling and depth so that I felt the ocean was flooding the city, bringing the beauty and serenity of nature to the forefront of busy people's urban lives. The murals demanded attention and joined other priorities as being important to our lives."

Jim Fowler, Scientific Animal Researcher

"Wyland is a phenomenon, a Johnny Appleseed, covering the land with his oceans and whales. He reminds me of the days of barnstorming and circuses coming to town. He's the daredevil going over Niagara Falls in a barrel or walking a tightrope between skyscrapers. He brings back a spirit that's been somehow missing, a uniquely American entrepreneurial celebration of freedom and possibilities and endless afternoons of realizing dreams."

Ken Twitchell, Muralist

"For the young artist, this was especially important because his love of the sea was inspired by Lloyd Bridges in his hit series, Sea Hunt.*"*

Robert Hays, Actor

"I was thinking of the many people in the City of Angels that have done great things for the world and environment and Wyland stands right at the top."

John McConnell, Founder of Earth Day and the Earth Society

"Wyland is a perfect example—he has taught us so much in all the years that I have known him; he has never lost sight of the real goal."

Mandy Rodriguez, Founder and President, The Dolphin Research Center, Marathon Florida

"Wyland, through his gift as an artist, has done a wonderful thing in bringing these beautiful sea creatures to all of us."

Joan Irvine Smith, Founder, The Joan Irvine Smith & Athalie R. Clarke Foundation; Founder, The Irvine Museum

"Cousteau made films and wrote books. Others take photographs. Some write, or sing or conduct research. Wyland paints, but he also conveys to an ever-widening audience his concern and passion for taking care of the natural systems that take care of us by involving us in spectacular, engaging, moving ways."
Dr. Sylvia A. Earle, Founder, DOER; Researcher in Residence, National Geographic Society

"Empowering young people through artistic expression is both effective and noble. I hope we'll have a chance to work together on these issues of common concern."
C. Richard Allen, President and CEO, National Geographic Ventures

"Your creative talents and your ongoing endeavors to inspire and educate young people about marine life and the beauty and fragility of the ocean are deeply appreciated. Through your paintings and murals, your public art, your research and teaching programmes you have encouraged thousands to join in respecting and preserving this precious resource. I also share and commend you on your theme: 'One person can make a difference' — a phrase I often use in my own public remarks."
Kofi A. Annan, Secretary-General, United Nations

"Congratulations on your Wyland Foundation's 50 States in 50 Days ocean bus tour. What a great opportunity to teach the children of our great country the diversity of the ocean world. You are to be commended for your tireless efforts to education."
Bob Miller, Governor, State of Nevada

"Your goal of educating all of America's children on the joys and wonders of the ocean is to be commended."
Dr. Robert Schuller, Reverend, The Crystal Cathedral

"I'm honored . . . to be a part of your project, and I think the Wyland Challenge is a wonderful way of engaging millions of children in the ocean and conservation."
Dr. Robert Ballard, Ocean Explorer

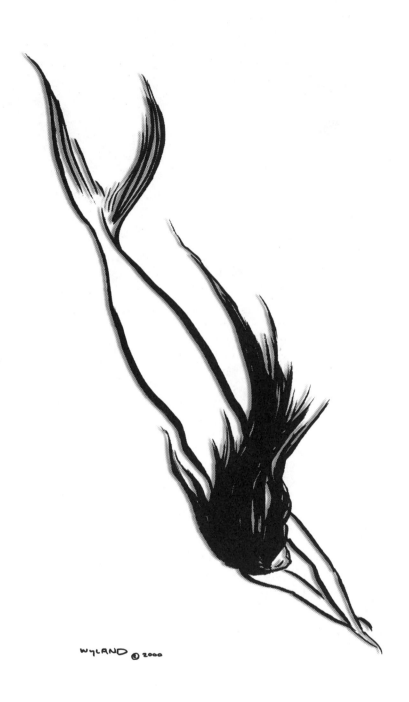

WYLAND © 2000

OCEAN WISDOM

Meditations and Art for the 21st century

THIS BOOK OF OCEAN WISDOM IS DEDICATED TO OCEAN PIONEERS,
Jacques-Yves Cousteau, Lloyd Bridges, Dr. Silvia A. Earle, Dr. Robert
Ballard, Kofi A. Annan, Ted Danson, Dan Fogelberg, Jimmy Buffett,
Bob Hunter, John McConnell, Dr. Roger Payne, Mandy Rodriguez,
and Reverend Dr. Robert Schuller and to all who have loved the
ocean as much as I do.

WYLAND

For more information on Wyland write:
 Wyland World Headquarters,
 5 Columbia
 Aliso Viejo, California 92656.
 w w w . w y l a n d . c o m

Publisher: Health Communications, Inc.
 3201 S.W. 15th Street
 Deerfield Beach, Florida 33442-8190

All original brush drawings by

WYLAND

I would also like to thank the Wyland Publishing Team: Angela Needham, Vice President of Publishing; Julie
Edwards, Editor; Gregg Hamby, Graphic Designer; Jonathan Dupree, Art Director, along with Kim Taylor
Reece and Jeff Pantukhoff for helping me finish this book, my fifth and maybe my most important.

Wyland, 1956

I hope this book will inspire a whole

generation of ocean protectors . . .

May we all now listen to the ocean's wisdom.

WYLAND

Foreword

Wyland is the artist's artist, the master's master and the man who is going to save the oceans. A friend to the whales, dolphins and all animals of the sea, this visionary artist/leader has invested his lifetime communicating why it is imperative that we save our precious oceans. He has astounded people with The Wyland World Tour, painted eighty-five Whaling Walls, and inspired 67 million American students, all the while bridging the worlds of art and science. He has befriended the world's who's who, including looming dignitaries such as Lloyd Bridges, Jacques-Yves Cousteau, Jimmy Buffet and Buzz Aldrin, inspiring them to help him save the oceans. Wyland's real appeal is to every man and to every woman, because they know if the oceans die, humanity dies.

Wyland Ocean Wisdom is a compilation of meditations that caress the heart, mind and soul with words that make the heart soar and remind each of us to remember why we love the oceans. Life came from the sea and as we enter a new millennium we need to reconnect with our ocean roots. *Ocean Wisdom* will remind you of all the joys experienced with the ocean; waves kissing your feet, sand squishing between your toes and the water lapping at your ankles. The ocean grounds us, centers us, and makes us feel wholly human. Wyland has captured these inspirational connections in prophetic epigrams.

To create this brilliant masterpiece, Wyland wrote over 500 affirmations, sutras and mantras over a ten-year period, and he has edited them down to over 100 perfect meditations and original brush art drawings for the twenty-first century. As you absorb these wisdoms, you'll want to put yourself in a serene environment, like a warm ocean sunset, or sit in your favorite reading corner. It is in this sort of setting that Wyland would like you to take the Ocean Lover's Pledge found on the next page. Lovingly ask three others to join you; place your right hand over your heart and your left hand up in official repose, and read the pledge out loud.

Wyland Ocean Wisdom takes you to the heavenly states of mind that you've always wanted to ascend to. By writing these thought bites for the soul into small, tasty, daily doses, Wyland has captured the essence of the ocean for everyone. Reading this delectable book will create a new love: respect and appreciation for our ocean mother.

Wyland and I have had the opportunity to penetrate the Earth's ocean blanket, which covers 70 percent of the Earth's surface. Few have experienced the Earth from the inside of the ocean and seen just how fragile our ecosystem is. When we emerged from the sea we decided to begin our joint crusade that would save the oceans and inspire people to make a difference. This book is the torch that is being passed on to you so that you can learn and pass onto others the desire to take part in this impassioned cause.

Wyland has courageously written the Ocean Lover's Pledge. I humbly and respectfully ask you to join me in this pledge to preserving the oceans of the world.

Mark Victor Hansen
Cocreator and Coauthor, *Chicken Soup for the Soul* Series

Ocean Pledge

I pledge to keep clean our oceans,
lakes, rivers and streams....

Wyland Foundation

Acknowledgments

It has been said that a picture is worth a thousand words; for me words inspired a thousand paintings over the past thirty years. The writings and words of ocean pioneers like Jacques-Yves Cousteau had a profound impact on my artistic life and caused me and a whole generation of young people to become more aware and sensitive to the plight of all life in the sea.

The amazing words of friends like Dr. Sylvia Earle and Dr. Roger Payne, quality time spent with ocean lovers like Lloyd Bridges and countless friends and supporters from three years old to ninety-three years old have inspired me to share some of my ocean wisdom.

This book is dedicated to all the great nature writers past and present who have shared their words of inspiration to many hungry for their words like myself. Heath Court Williams, Henry David Thoreau, Edward Abbey, John Muir and many Native American Indians inspired me to write my thoughts in this book. I was greatly influenced by the great works of these and many other inspired environmentalists who cared enough to share their art with all who cared to listen. I hope to contribute in some small way to the conservation of our oceans through these words of wisdom and my art, with meditations for a new millennium.

Introduction by :ᴡᵧʟᴀɴᴅ

As we enter the birth of a new millennium and reflect on the last, we begin to see our place here on Earth.

Some of us hold on to hope as the twenty-first century begins anew; a challenge to each of us to reverse the damage caused by us and our ancestors and to begin to finally become protectors and not predators of the blue planet we call home.

Today, each of us must embark on a journey of self-discovery. We must all begin to see all humans and animals not only with our eyes but also with our hearts.

We humans are blessed with the ability and vision to make a difference in our world. It begins with each and every one of us as we grow, love and learn.

Rededicate yourself to nature. Give something back to our beautiful natural world on land and in the sea. The plight of the oceans is in each of our caring hearts and hands. Each of us can have a huge impact on saving the planet. It begins with you. Share the wisdom of the sea with your family and friends and all who care to listen.

Let this book be your personal call to action. Be part of the solution and not the problem. Begin the journey to save the Earth in your own backyard. Happy journeys.

Best Fishes and Aloha,

:ᴡᵧʟᴀɴᴅ

North Shore, Oahu, Hawaii, 1999

Wyland

OCEAN WISDOM

WYLAND © 2000

We must not only see whales with our eyes,
but with our hearts...

WYLAND © 2000

*If the oceans are calling, it must
be the song of the whales...*

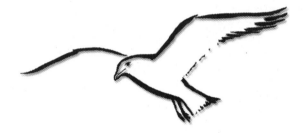

WYLAND © 2000

You don't have to live in the ocean

to want to protect it...

WYLAND © 2000

One person can indeed make a difference...

WYLAND © 2000

The life within the sea will flourish

without the progress of man...

WYLAND © 2000

We have no reason to poison the very
thing that brings us life...

WYLAND © 2000

We have no reason to hunt whales;

they are much more valuable alive...

WYLAND © 2000

All of man's masterpieces in art can't match the living treasures in the sea...

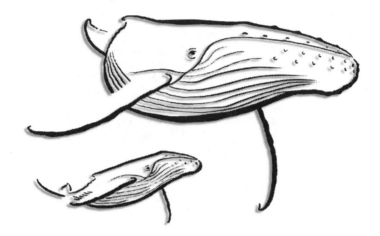

WYLAND © 2000

Can we live without whales?
I hope we never find out...

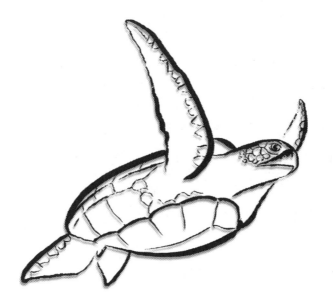

WYLAND © 2000

Life began in the sea and so did we...

WYLAND © 2000

Whales today are a symbol of people's desire
to protect our ocean planet...

WYLAND © 2000

The great strength of whales has little
to do with their size...

WYLAND © 2000

The larger picture is not only

can we save the whale, but also

can we save our oceans, our planet, ourselves?

WYLAND © 2000

28

Even after the many years
of slaughtering, whales have always
been friendly to man...

WYLAND © 2000

We have much to learn from the whales,
they are much more valuable
to us alive ... we must save them ...

WYLAND © 2000

Only in today's time have our
great oceans become threatened,
we must save man from himself...

WYLAND © 2000

34

The twentieth century has seen the
depletion of many species.
Some may never recover. . .

WYLAND © 2000

Many marine species face complete
extinction unless man changes
his lifestyle...

WYLAND © 2000

38

Today we celebrate living whales...

WYLAND © 2000

Clean water and a healthy ocean are

important to everyone...

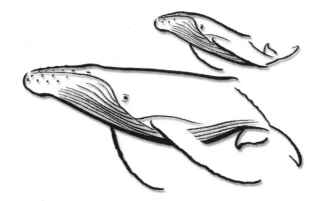

WYLAND © 2000

42

I dream of places where man has never been,

only great whales...

WYLAND © 2000

To master the oceans, we must first respect all life within...

WYLAND © 2000

Nature can teach us far more than the finest universities...

WYLAND © 2000

We honor nature, we honor ourselves...

WYLAND © 2000

It is wrong to take whales and dolphins from the sea. They must now be appreciated in their natural habitat...

WYLAND © 2000

Will we be the generation that cares
enough to help all life on this planet?

WYLAND © 2000

I like dolphins because they seem
to celebrate each and every moment
with pure joy. . .

WYLAND © 2000

In the oceans, dolphins have thrived without killing their own kind...

WYLAND © 2000

In the sea, life will continue long after man...

59

WYLAND © 2000

The undersea pallet is the most
colorful in the universe...

WYLAND © 2000

62

I believe if the whales go
we are certainly next...

WYLAND © 2000

Man is the most dangerous
predator in the sea...

WYLAND © 2000

Oceans are a place to look for inspiration . . .

WYLAND © 2000

The greatest symphonies are conducted
not by man, but by great whales. . .

WYLAND © 2000

The butterfly fish, like the butterfly,
flitters from flower coral to flower coral
care-taking our coral gardens...

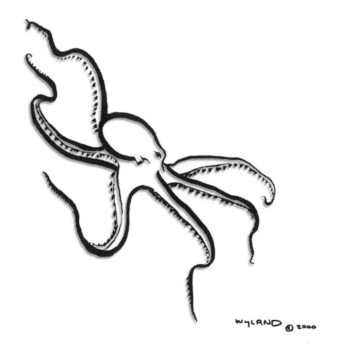

WYLAND © 2000

72

For me I love the sea...

WYLAND © 2000

Oh, what fun it must be for dolphins to see humans clumsily trying for a short time to enter their world where man would finish last in an ocean Olympics...

WYLAND © 2000

It is now up to us to continue the message of Captain Cousteau and to be good stewards of the seas...

WYLAND © 2000

The ocean delights in showing its awesome
beauty to all that come to visit...

WYLAND © 2000

Always remember that the ocean delights in feeling your feet in her eternal bath . .

WYLAND © 2000

Only in nature does one truly live...

WYLAND © 2000

We feel a kinship with whales and dolphins;
they, like us, came from the sea...

WYLAND © 2000

The sea has been an inspiration to all that
encounter her...

WYLAND © 2000

The moment we enter the sea,

we are reborn...

WYLAND © 2000

When man hunted the large blue whales,
almost to extinction, and could find
no more, he began to kill other
smaller species...

WYLAND © 2000

92

The blue whale, largest animal to ever inhabit the Earth, could only exist in the buoyant sea...

WYLAND © 2000

Whales have yet to recover their original numbers, they probably never will...

WYLAND © 2000

The gentle, caring nature of the whale
should be adopted by man...

WYLAND © 2000

Today, a great many people care about all forms of life on our planet...

WYLAND © 2000

When we care enough
we begin to take action...

WYLAND © 2000

102

What is it in our nature that allows us to destroy other species that we know little about until they are gone?

WYLAND © 2000

The sea is an endless orchestra
of light and sound...

WYLAND © 2000

There, below the surface, are great forests growing from the bottom of the sea...

WYLAND © 2000

Try to Imagine a planet where you could not drink the water...

WYLAND © 2000

If children grow up with a vision of life in the sea they will protect it...

WYLAND © 2000

Once a child loves an animal
they will forever defend it. . .

WYLAND © 2000

Now that whale hunting is coming to a
close will we poison the life-giving sea?

WYLAND © 2000

116

We are stewards of our planet

one and all...

WYLAND © 2000

In reality, the ocean will survive,

but will we?

WYLAND © 2000

120

The magic spell cast by the sea enlightens all that embrace her...

WYLAND © 2000

The wandering albatross glides effortlessly
above the sea held up by her breath . .

WYLAND © 2000

Maybe you have seen God's aquarium;
it's called the sea...

WYLAND © 2000

The ancient Greeks felt killing a dolphin was the equivalent of killing a human; the penalty was the same as for murder...

WYLAND © 2000

Whales and dolphins survive without aggression toward other species...

WYLAND © 2000

Dolphins celebrate the true joy of living each and every day...

WYLAND © 2000

132

Whales are a symbol of the wild oceans,
unchanged for millions of years...

WYLAND © 2000

Once a dolphin enters your heart

it can never be removed...

WYLAND © 2000

In the ocean world, older and more evolved
than ours, whales move with senses we have
never been given, gliding effortlessly
through a world man could not survive in
for even a day...

WYLAND © 2000

The most insignificant ocean animal

is significant to the balance

of the oceans...

WYLAND © 2000

Turtles glide through the sea weightless, moving effortlessly like sea birds dancing in the clouds...

WYLAND © 2000

142

The gap between marine mammals and humans is smaller than we think...

WYLAND © 2000

Orcas will only hunt for their precise needs, never taking more and always leaving enough to renew the species...

WYLAND © 2000

No animal works harder at having fun
than the dolphin...

WYLAND © 2000

Small as he is, the garibaldi knows
very well he's a beast of prey...

WYLAND © 2000

The ocean stirs the heart, inspires
the imagination and brings
eternal joy to the soul. . .

WYLAND © 2000

The best art can be discovered in nature...

WYLAND © 2000

The sea wears a blanket to cover
her hidden treasures...

WYLAND © 2000

The sights and sounds of the sea

always inspire...

WYLAND © 2000

To those who love the sea, she speaks...

WYLAND © 2000

Consult nature and you will
never be disappointed...

WYLAND © 2000

The best gift in life comes from simple
things, like a walk on the beach with
the sound of the waves churning
and clearing your mind for new dreams...

WYLAND © 2000

164

The world's finest wilderness lies
beneath the waves...

WYLAND © 2000

166

Each day and night the sea composes a symphony...

WYLAND © 2000

168

I have compassion for man,
but more for animals...

WYLAND © 2000

Into the ocean went a world more fantastic

than any imagination

could inspire...

WYLAND © 2000

We hold in our heart the will

to protect all species...

WYLAND © 2000

No one can write knowingly of whales;
they will always remain a mystery...

WYLAND © 2000

176

Nature... let it in you...

WYLAND © 2000

178

The big blue sea is where I long to be...

WYLAND © 2000

Mermaid, siren of the sea,
I believe in thee...

WYLAND © 2000

Many ocean species have yet
to be discovered...

WYLAND © 2000

Over two-thirds of the planet is covered by seawater, yet we continue to call it Earth...

WYLAND © 2000

It is thought sea turtles use the stars
to navigate the vast oceans,
returning years later to the very beach
where they were hatched...

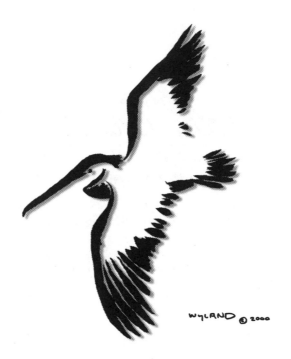

WYLAND © 2000

188

The sea is millions of years old; maybe that's why it tastes funny...

WYLAND © 2000

Great whales graze on plankton in the rich
pasture of the sea...

WYLAND © 2000

192

Coral reefs are the gardens of the sea,
as rich and colorful as any on land...

WYLAND © 2000

Did starfish fall from the sky
and make their home in the sea?

WYLAND © 2000

The dolphin is man's best-finned friend...

WYLAND © 2000

The legendary albatross was thought to be
a good omen to ancient mariners...

WYLAND © 2000

200

How surreal to happen upon a flying fish,
gliding effortlessly across the surface,
momentarily leaving its watery home
for loftier worlds...

WYLAND © 2000

The best fishermen are not men, but fish . .

WYLAND © 2000

Narwhals, unicorns of the sea...

WYLAND © 2000

206

Whales have navigated the world's oceans
for millions of years before man...

WYLAND © 2000

The world's water supply is being threatened
by overpopulation and man-made problems;
there is a finite supply of clean water that
must be protected
and preserved by everyone...

WYLAND © 2000

Sharks don't like the taste of man;
does this mean man does not have
a good taste to sharks?

WYLAND © 2000

Fish, seafood and eat it...

WYLAND © 2000

Some ocean islands are the
moving backs of great whales...

WYLAND © 2000

Only in the past few years have we really begun to explore the vastness of the oceans only to find how fragile they are and our place in them...

WYLAND © 2000

218

When ancient mammals left the land
to seek food in the sea, their arms changed
into flippers, their legs into powerful tails
and their bodies into streamlined
perfection in their new watery home...

WYLAND © 2000

*Whales have the widest smiles
in the animal kingdom...*

WYLAND © 2000

*Dolphins live in the womb
of Mother Ocean...*

WYLAND © 2000

Dolphins take pleasure in play: jumping,
somersaulting and creating games
and athletic contests, not to win,
but simply to live...

WYLAND © 2000

226

The songs of the whales were long thought
to be haunted spirits of the deep...

WYLAND © 2000

Each whale tribe has a different voice
of the deep that tells of their ancient
history passed on to future generations
and added to each year...

WYLAND © 2000

230

Lone humpback whales may sing solo
for days on end in search of a mate...

WYLAND © 2000

Without the blue whale's attention,

oxygen-producing plankton would

overpopulate uncontrollably, thus raising

the temperature of the sea, creating

a catastrophe that could never be reversed. . .

WYLAND © 2000

We can only awe at the sight of whales
leaving the water, catapulting their
enormous bodies from the sea as they,
for a brief moment, enter their past world...

WYLAND © 2000

236

Whales mate belly to belly, holding
each other in their flippers,
touching and caressing. . .

WYLAND © 2000

Man needs to rethink his relationship with nature...

WYLAND © 2000

In the sea, whales have become the
dominant species, not by killing each other,
but by respecting all life...

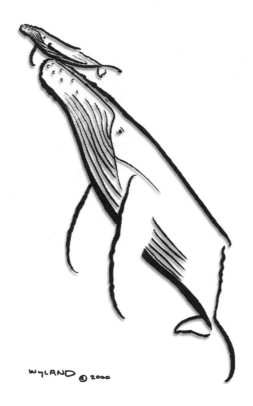

WYLAND © 2000

242

Whales control their own population
in direct relationship to the supply
of food in the ocean...

WYLAND © 2000

Dolphins are intelligent ocean angels who desperately need the love and compassion of all men...

A New Beginning

January 1, 2000

OCEAN FACTS

1. The oceans cover an area nine times larger than the surface of the moon.
2. Oceans contain 97 percent of all water on the planet.
3. Ocean sounds travel over four times faster than on land.
4. It is not the rain forest that produces most of the Earth's oxygen but the sea.
5. Algae produces over half of the Earth's oxygen.
6. Seashells are found on Mount Everest, which was once part of the ocean floor.
7. All life on our planet began in the sea.
8. Under the sea the landscape is as varied as any on Earth.
9. No light enters the ocean realm below 3,000 feet.
10. The deepest part of the ocean is over 36,000 feet below sea level.
11. The largest ocean wave, called a tsunami, was 278 feet high.
12. Ocean waves are caused by wind blowing across the surface for thousands of miles.
13. Sand is made from rocks worn down by wind and rain and ocean currents over thousands of years.
14. Giant coral reefs are formed by tiny sea animals called polyps.
15. Coral grows at the same rate as fingernails and is manicured by small fishes and other sea creatures.
16. Coral reefs are home to millions of creatures.
17. The 15 million-year-old Great Barrier Reef is the Earth's largest reef, so large that it can be seen from the moon.
18. The seahorse is the slowest fish in the sea.
19. A blue whale may eat up to four tons of krill a day.
20. Most sea life lives near the surface where it is warm and sunny.
21. Deep down in the abyss live creatures yet undiscovered.
22. The deepest dive by a scuba diver is only 436 feet.
23. About 65 million years ago, the ancestors of whales and dolphins lived on land.
24. Blue whales have the largest babies, with some weighing over five tons.
25. A blue whale's tongue weighs more than thirty-five men.
26. A sperm whale can hold its breath for two hours and dive to depths of 10,000 feet.
27. Sea lions can swim at speeds of twenty-five miles per hour.
28. There are over 300 species of sea birds.
29. The wandering albatross' wingspan can measure nearly twelve feet.
30. The huge whale shark is the largest fish, at sixty feet long and weighing twenty tons.
31. The giant manta ray can measure over twenty-five feet long and weigh over two tons.
32. The Pacific covers about one-third of the Earth's surface.

33. Where sea turtles travel is an ancient mystery to man. From the time they are hatched on the beach until many years later when they return to lay their own eggs, they are not seen by man.
34. Each year we remove over 60 million tons of fish from the ocean.
35. Over 80 percent of ocean pollution comes from the land.
36. Raw sewage is pumped into the ocean every day.
37. Poisonous metals from factories are dumped into the sea having a disastrous effect on all life that exists there.
38. Nuclear waste is dumped into the sea without regard for the life that lives there.
39. Dangerous chemicals, fertilizers and pesticides are washed off the land by rains and carried to the sea by lakes, rivers and streams having a devastating impact on the ocean habitat.
40. Oil and petroleum are dumped into the ocean each day creating catastrophic implications for all life on the planet.
41. Fish are being pulled from the sea faster than they can reproduce; some may never recover their original numbers.
42. We are now suffocating our sea.
43. Discarded drift nets roam the sea indiscriminately killing everything in their path for years and years.
44. The oceans are being used as a dump sight by uncaring humans.
45. Many sea animals have already become extinct.
46. The Mediterranean monk seal is one of the most endangered animals and will certainly become extinct without an all-out effort to protect it.
47. Sea-monster legends probably were based on the giant squid, never a threat to man.
48. Greek legend tells of a dolphin saving humans at sea by offering a drowning seaman a ride to shore on its back.
49. Whales and dolphins live in a medium 800 times denser than air.
50. Dolphins move in a never-ending sea of sound.
51. A whale's body contains as many living cells as the entire human population of the Earth.
52. Plankton is where most of the Earth's oxygen comes from.
53. Throughout the world each year, more than 60 million tons of food is harvested from the sea.
54. It is estimated that there are 20,000 species of fish.
55. Some fish give birth to their living young.
56. Fish can live a few weeks to fifty years or more.
57. Most fish are color-blind.
58. Fish can get seasick.
59. The dolphin is closely related to the true porpoise.
60. Dorado, the dolphin fish, have been clocked at forty miles an hour.
61. Porpoises are descendants of land mammals who probably went back to the sea 50 or 60 million years ago.

62. The dolphin is the friendliest creature in the sea.
63. Dolphins were represented on coins in ancient Greece.
64. The dolphin is a cosmopolite animal inhabiting every sea from the equator to the Poles.
65. Dolphins are often seen swimming just ahead of the bow of ships, attaining speeds of up to thirty-five miles an hour.
66. Dolphins can hitch a ride for miles on compression waves caused by the forward motion of a ship.
67. Sailors have told many tales about dolphins guiding their ships through dangerous passages.
68. Dolphins, which travel in schools of up to 100, are air breathers like porpoises and must rise to the surface every seven minutes or so.
69. Proportionately, dolphin brains are almost as large as human ones.
70. Young dolphins, or calves, are born tailfirst to prevent them from drowning during the birth process.
71. As soon as the dolphin calf is born, the mother pushes the limp, floppy, three-foot-long calf to the surface for its first breath of air.
72. Female dolphins can only give birth every two years or so.
73. The care of a baby dolphin is as demanding as that of a human baby.
74. Dolphins have a normal life span of twenty to forty years.
75. Dolphins have been known to support sick or injured companions and even drowning humans in the water.
76. Dolphins have kept shipwrecked sailors afloat for days.
77. When sharks threaten a dolphin, they are rammed so hard in the gills by the dolphin's powerful beak that they are often killed.
78. Dolphins often sleep with one eye open.
79. Dolphins and whales manage to stay warm because of the thick layer of blubber beneath their skin.
80. Dolphins have 160 to 200 teeth.
81 The spinner dolphin has the interesting habit of leaping into the air and whirling like a spindle before falling back to the sea.
82. Unlike most animals that are friendly to man, the dolphin has no need for us.
83. Dolphins make ultrasonic noises pitched so high they cannot be detected by the human ear.
84. Dolphins use sonar for navigating under the water and for locating food.
85. Porpoises swim with schools of tuna, which are caught in huge seine nets.
86. The study of whales began with Aristotle, who correctly observed that dolphins and whales were not fish but air-breathing mammals.

87. It was not until the mid-twentieth century that scientists developed methods for studying whales and dolphins that would neither harm nor interfere with their natural movements.
88. The order of whales contains as many as ninety or more living species.
89. There are two existing orders of sub-whales today, the *Mysticeti* (baleen whales) and the *Odontoceti* (toothed whales).
90. The largest of the toothed whales is the sperm whale – the males can grow to more than fifty feet long and weigh over sixty tons.
91. It is believed that the air-breathing cetaceans actually evolved from land mammals who returned to the sea.
92. Cetaceans do resemble fish but are actually much closer to the carnivores and hoofed animals on land.
93. The earliest cetaceans began life in the water sometime during the Cretaceous Period about 50 million years ago.
94. Dolphins and porpoises can move easily at twenty-five knots for a long period of time.
95. Baleen whales have two blowholes creating a double spout.
96. Some whale species may dive or remain submerged for more than an hour on a single breath of air.
97. A whale cannot breath through its mouth.
98. Baleen whales feed primarily on krill.
99. Toothed whales swallow their prey whole rather than chewing them.
100. Whales have three stomachs.
101. Water is an excellent conductor of sound, and communication between individual whales has been known to take place over hundreds of miles.
102. Whales have stranded on land since the beginning of history.
103. Like birdsong, the humpback whale's songs seem to play a role in courtship and defense of territory.
104. Humpback whales sing their song only six months of the year.
105. Individual whales can be identified by their song.
106. Humpback whale songs consist of short phrases and evolve continuously each year.
107. Amazingly, individual whales pick up the same song at the same location after their sixth month of silence ends.
108. The earliest form of shark-like fishes developed over 300 million years ago.
109. The families of sharks in existence today have changed little since they appeared some 60 million years ago.
110. Sharks can detect minute traces of blood in the water over a quarter of a mile away.
111. The shark species most frequently reported in attacks on humans are large hammerheads, tiger sharks, bulls, blues, makos, oceanic white tips, and the great white.

112. The white shark is one of the largest carnivorous fish, some growing as large as twenty-five feet in length.
113. Sharks' species range in size from the pygmy shark, which is less than a foot in length, to the huge whale shark, which can grow to sixty feet and weigh over 90,000 pounds.
114. The mako shark is a loner and does not travel in schools.
115. The only bones the shark has are its teeth and jaws.
116. Some sharks can swallow anything half their size in one gulp.
117. The fastest fish is the sailfish, which has been clocked swimming at over sixty-eight miles per hour.
118. Penguins can swim up to twenty-five miles an hour.
119. The male emperor penguin hatches the female's single egg for sixty-four days in subzero temperatures.
120. Albatross' possess the largest wingspan of all birds, some in excess of twelve feet.
121. The brown pelican's pouch can hold over two gallons of water.
122. Although the penguin is a bird, it cannot fly.
123. Seagulls can live for up to twenty-eight years.
124. Manta rays leap out of the water to give birth while airborne.
125. The triggerfish, also known as humuhumunkunukn-aapuaa, grunts like a pig.
126. After twenty-five days, the world's only pregnant father, the sea horse, releases hundreds of baby sea horses out of his pouch one by one.
127. The largest sea turtle on record is a Pacific leatherback, weighing nearly 2,000 pounds and measuring over eight feet in length.
128. The green sea turtle can grow to weigh over eighty-five pounds.
129. Turtles are the longest living of all vertabrates on Earth, surviving up to two centuries.
130. Like all turtles, sea turtles are reptiles.
131. A sea turtle's sex can be told by the length of their tails – a male's is long, a female's is short.
132. Sea turtles can stay under water for up to forty minutes before surfacing for air.
133. Turtles navigate by the stars.
134. The longest-lived animal in the world is the giant tortoise, which weighs more than 600 pounds and lives up to 200 years.
135. It is estimated that some 100 of the 25,000 fish species are poisonous to humans.
136. There is one record of thirteen porpoises and fourteen seals taken from the stomach of a single killer whale.
137. A killer whale, also called an orca, is technically a large dolphin.
138. Killer whales do not eat humans.
139. An orca's life span is estimated at thirty to forty years.
140. Despite a lack of external ears, the hearing of killer whales is well tuned to the sounds in its watery world.

141. Orcas have some forty-odd pointed teeth, each one longer than the fangs of a tiger.
142. There are few animals in the sea or on land that show evidence of any greater intelligence than the killer whale.
143. Some scientists think that orcas may be the most intelligent beast alive.
144. One blue whale specimen was measured at over 110 feet long and weighed 200 tons, more than fifty full-grown elephants.
145. The blood vessels of a blue whale are so large that a full-grown trout could swim through them.
146. Blue whale calves grow faster than any living animal, attaining a weight of about twenty-nine tons in a two-year period.
147. Blue whales can live off their blubber, without any other food, for more than half a year.
148. Giant squids can reach over fifty feet in length.
149. There is enough salt in the ocean to cover all the continents with a layer 500 feet thick.
150. The weight of all the water in the sea is 1.2 quintillion tons.
151. Earth contains 350 million cubic miles of sea water.
152. Ocean waters cover 72.9 percent of the earth's total surface.
153. Melt all the ice in the world and the oceans would rise about 180 feet.
154. If divided up, the world's oceans would provide 110 billion gallons of water for each person.
155. There are more like seventy-seven seas rather than the presumed seven around the world.
156. The 100-foot blue whale weighs over 150 tons—much larger than even the largest dinosaur.
157. Dolphins are small, toothed whales.
158. The blue whale makes the loudest sound of any animal on the planet, louder than a 747 jumbo jet.
159. The blue whale may weigh two to three times more than the largest dinosaur.
160. Moby Dick was actually an albino sperm whale.

W Y L A N D
ACCOMPLISHMENTS

ARTIST ° PAINTER ° SCULPTOR ° MURALIST ° WRITER °
UNDERWATER PHOTOGRAPHER ° DIVER

BORN: 1956, Detroit, Michigan

EDUCATION: Center for Creative Studies, Detroit, Michigan

MAJOR EXHIBITIONS:
Vancouver Aquarium, British Columbia, Canada
Marineland, Palos Verdes, California, USA
Sea World, San Diego, California, USA
Sea Life Park, Honolulu, Hawaii, USA
Wyland Galleries, USA/Hawaii
Waikiki Aquarium, Honolulu, Hawaii, USA
Polynesian Cultural Center, Laie, Hawaii, USA
Collectors Choice Gallery, Laguna Beach, California, USA
Center for Creative Studies, Detroit, Michigan, USA
Wild Wings Gallery, Fort Myers, Florida, USA
Upstairs Gallery, Palos Verdes, California, USA
Sawdust Festival, Laguna Beach, California, USA, twelve years
Art Expo, Los Angeles, California, USA
Art Expo, New York, New York, USA
Catalina Art Festival, Santa Catalina Island, California, USA
Ellis Island Museum, New York, New York, USA
Provincial Museum, Victoria, British Columbia, Canada
Smithsonian Institute, Washington, D.C., USA
Bunkamura, Tokyo, Japan
Festival of the Whales, Dana Point, California, USA
Prince's Trust, London, England
Royal Ontario Museum, permanent collection, Toronto, Ontario,
 Canada
Nice, France
University Science Museum, Mexico City, Mexico
Sydney Aquarium, Sydney, Australia
Aquarium of the Americas, New Orleans, Louisiana, USA
Crystal Cathedral, permanent collection, Garden Grove, California,
 USA
New Zealand National Maritime Museum, Auckland, New Zealand

AWARDS:
The Senate of the State of Hawaii, Certificate of Appreciation
Arts Council, City of Laguna Beach, California
Greenpeace Award, 1985
Who's Who in American Art
Sawdust Festival Awards, 1983, 1984 and 1986, Best of Show
Conservation Council of Hawaii, Award

1991 Paloma Award, Los Angeles Society for Prevention of
 Cruelty to Animals
Key to the City of White Rock, British Columbia, Canada
"Wyland Building", Vancouver, Canada
Resolution, City of Laguna Beach, California
Key to the City of Redondo Beach, California
Beautification Award, Redondo Beach, California
Guinness Book of World Records, Largest Mural, March, 1992
Dolly Green Award – Genesis Awards
Citation and Commendation, Senate and General Assembly
 of New Jersey
Congressional Tribute to Wyland, 103rd Congress of the
 United States
Genesis Award, The Ark Trust, Presented by Loretta Switt
Best Artist, *Hawaii Magazine*
Best Public Art, Reader's Choice, *OC Weekly*, Orange County,
 California
Beautification Award, Hollywood, California
Key to the City, Cleveland, Ohio, September 1997
Earth Day Peace Bell Award, United Nations, New York City, 1998
Airbrush Action, Vargas Awards, June 1998
United Nations Artist of the Year for the "International Year of the
 Ocean", 1998
NOGI Award, Underwater Arts & Sciences, January 1999
Nominated, Horatio Alger Award, June 1999
The Inc. 500: The Fastest-Growing Private Companies" Wyland
 Studios, *Inc. Magazine* (September 1995)
Detroit Walk of Stars, Detroit, Michigan

PROCLAMATIONS
In nearly every city and state that Wyland has painted and
dedicated a wall in or exhibited his art in, the mayor and / or
governors have declared that day or week, "Wyland Day" or
"Wyland Week". Wyland's list of proclamations numbers well over
two hundred.

PUBLICATIONS
*Aloha Magazine, Sea Coast Magazine, Oceans Magazine,
Cousteau Log, Greenpeace Examiner, Honolulu Advertiser,
Vancouver Sun, The Province, Art Gallery International,
Vegetarian Times, Now Magazine, McCleans Canada, Los Angeles
Times – Calendar, Los Angeles Times – Business, This Week
Oahu, Orlando Sentinel, Ocean Sports International, Sea
Magazine, Orange County Register, Daily Pilot, Tides & Illustrated,
Maui News, The Hawaii Hochi, Daily Tribune, The Reader,
Southwest Art Magazine, Westways, Waterfront Magazine, UPI
Feature, People Magazine, People Magazine of Japan, This Week
Maui, Fortune Magazine, Inc. Magazine, Kauai Times, Long Beach
Telegram, The Oregonian, Portland Press Herald, Maine Sunday
Telegram, Portsmouth Herald, The Portsmouth Press, Fosters
Daily Democrat, Boston Globe, Boston Herald, Providence Journal*

Bulletin,New York Times, The Day (Connecticut), *The Philadelphia Inquirer, Dallas Morning News, The Met, Park Cities People, Downtown Business News, The Press of Atlantic City, The Star Ledger* (New Jersey), *The SandPaper, The News Journal* (Delaware), *The Washington Post, The Sun* (Maryland), *The Miami Herald, The San Diego Tribune, U.S. Art Magazine* (cover), *Guiness Book of World Records* (record holder), *National Geographic World* (cover feature), *Friday Magazine Japan* (feature), *Forbes Magazine, Reader's Digest, Chicago Tribune Magazine, Success Magazine* (cover feature), *AP features, NEA Today, Time Magazine, Air Brush Action Magazine, Orange County Exclusive, National Marine Sanctuaries Accomplishments Report, Adventure West Magazine, Creative Living, Canadian Wildlife, Laguna South Coast Lifestyle, South Coast, USA Today.*

TELEVISION FEATURES

PM Magazine – National, NBC – National, ABC – National, KITV ABC Word for Word, Eyewitness News – Detroit, CNN News Network, Impact WOFL-Channel 35, Playboy Channel, Hawaiian Moving Company, Heartbeat of the Public, Vancouver Show, Animalia-French National TV Feature, 24-Hour TV – Japan – National, Wyland Galleries Hawaiian Pro Surfer, Discovery Channel – Genesis Awards, *CBS This Morning, The Today Show*, QVC-2 hour specials, *Good Morning Australia*, Discovery, A&E, PBS, Front Runners, CNN (world feature), *Entertainment Tonight* (feature), *American Journal, Mike & Matty Show, The Today Show* (feature), *Good Morning Texas, The News of Texas, Hour of Power with Dr. Robert Schuller* (two shows).

FILMS / VIDEOS

Wyland – "The Art of Saving Whales" – Narrated by
 John Hillerman
Wyland – PBS special – "Whaling Wall 31" – Narrated by
 Leonard Nimoy, half-hour show
Wyland – "The Art of Wyland" – half-hour television special –
 Hosted by Lloyd Bridges
Wyland – "Wyland, The Whaling Walls" – one-hour television
 special – Hosted by Pierce Brosnan
Wyland – "Wyland's Ocean Planet" – thirteen episodes –
 Discovery's *Animal Planet*
Wyland – "The First Annual Wyland Foundation Awards" –
 two-hour television special – Hosted by Pat Morita
 and Julie Moran
Wyland – "Ocean Quest" – Baywatch – Guest Star
ANIMATION
Sea Walker Series
Wyland's Studio Sea
Spouty
Marine Core

BOOKS
The Art of Wyland – Robert Bateman, Introduction
Wyland – *The Art of Saving Whales*
Whale Tales – Biography and Short Stories by Wyland
Celebrating 50 Wyland Whaling Walls – Dr. Roger Payne,
 Introduction
Wyland – The Whaling Walls – reprint and update of *Celebrating
 50 Wyland Whaling Walls*
Guiness Book of World Records, 1995, 1996 (feature)
Artists of Hawaii (feature)
The Undersea World of Wyland – Time-Life Books
The Legend of Sea Walker
Chicken Soup for the Ocean Lover's Soul – Wyland, coauthor
Chicken Soup for the Earth — Wyland, coauthor

PRIVATE COLLECTIONS
President Ronald Reagan, Pilar Wayne, James Irvine,
Robert Redford, John Hillerman, Tom Selleck, Dick Dale,
Glen Frey, Bill Toomey, Cleveland Armory, Jacques-Yves Cousteau,
Robert Bateman, Linda Blair, Governor Bob Graham – Florida,
Prince Charles, Gannett Publishing – *USA Today*, Russ Francis,
Dan Marino, LeRoy Neiman, Governor Arioshi – Hawaii,
Dan Fogelberg, Jimmy Buffett, Barbara Whitney – Whitney Gallery,
Allain Bougrain-Dubourg, Lee Iacocca, Kareem Abdul-Jabar,
Pierce Brosnan, Paul Newman, Jim Fowler, Dennis Conner,
Dr. Roger Payne, Dr. John Ford, Bobby Hurley, Kevin Green,
Coach John Robinson, Secretary General United Nations – Kofi
Annan, Joan Irvine Smith, Dr. Robert Schuller, Dr. Sylvia Earle,
Hootie and the Blowfish, Tara Lapinski, Herschel Walker, Mayor
Richard Daley, Mayor Michael White, David Hasselhoff,
Magic Johnson.

MUSEUMS
Provincial Museum, Victoria, B.C., Canada – "A-5 Pod," original oil
 5 ft. x 6 ft.
Ellis Island Museum, New York "Aloha Liberty," original oil
Royal Ontario Museum, Toronto, Ontario, Canada – "Eye of the
 Whale," original oil (9 ft. x 70 ft.)
New Zealand National Maritime Museum, Auckland, New Zealand

CHARITY AND CONSERVATION
Founder of the Wyland Foundation – 1993
Memberships:
American Cetacean Society
American Oceans Campaign
American Protection Institute
Animal Welfare Institute
California Marine Mammal Center
Center for Action – Endangered Species
Center for Environmental Education
Center for Whale Studies
Cetacean Society International
Conservation International
Cousteau Society
Defenders of Wildlife
Earth Trust
Environmental Defense Fund, Inc.
Friends of the Earth
Friends of the Sea
Friends of the Sea Lion
Friends of the Sea Otter
Fund for Animals
Greenpeace
Greenpeace International
International Fund for Animal Welfare
International Rivers Network
Marine Artist Society
Marine Mammal Fund
Marine Mammal Stranding Center
National Audubon Society
National Geographic
National Wildlife Federation
Natural Resources Defense Council
Ocean Research & Education Society
Oceanic Society
Oregon State University
Save Our Seas
Save the Manatees
Screen Actors Guild
Sierra Club
Society for Marine Mammalogy
The Humane Society of the United States
The Wilderness Society
United Nations Environment Programme
W. Quoddy Marine Research Center
Whale Center
Whale Museum
Whale Protection Fund
Whale Research & Conservation Fund
World Wildlife Fund

EVENTS

Wyland The Whaling Walls East Coast Tour, 1993, 17 Murals,
 17 Cities, 17 Weeks
Wyland The Whaling Walls West Coast Tour, 1994, 13 Murals,
 8 Cities, 8 Weeks
Wyland The Whaling Walls Midwest Tour, 1997, 7 Murals, 7 Cities,
 7 Weeks
Featured Artist – Festival of Whales, Dana Point, California
Featured Artist – Jazz Festival, New Orleans, 1997
Completed Wyland Ocean Challenge of America Tour – 50 States
 in 50 Days. Reaching over 120,000 public and private schools
 and 67 million students, Fall, 1998.
Scripps Birch Aquarium Whale Day with Wyland, January 1999
Scripps Birch Aquarium Weekend with Wyland, January 2000
Featured Artist – 2000 America's Cup, Aloha Racing
2000 America's Cup Whaling Wall in New Zealand

WYLAND FOUNDATION ACCOMPLISHMENTS

Completed 85 Life-size Whaling Wall Murals
An estimated 1 billion people view Wyland Foundation public art
 projects annually
Supports numerous research programs over the years
Presentations to over 200,000 children, schools and environmental
 groups
Conducted the *National Geographic World Magazine* Ocean Art
 Contest
Lends support to over 100 conservation groups
Funds student scholarships
Conducted the Wyland Ocean Challenge of America 50 States
 in 50 Days Tour
Implementing the Wyland Ocean Challenge – Clean Water 2000
 nationwide

MISSION

To inspire a whole generation of people to a greater awareness to care more about our oceans and life within them, and to encourage people to become involved.

VISION

To promote, respect and protect our precious oceans resources through life-size public art, education and awareness.

THEME

One person can make a difference.

WE WILL:

• Promote the benefits of marine and environmental education

• Be good teachers and students of conservation

• Share the Foundation's values with all people throughout the world

• Make a difference in this world

• Lead efforts for clean water and a healthy ocean

• Continue to focus attention on ocean issues, good and bad

• Inspire children to find a way to contribute to saving our oceans and make a difference

• Continue to donate a portion of our proceeds to groups and individuals that care for our environment

Ocean Pledge

I pledge to keep clean our oceans,
lakes, rivers and streams....
 Wyland Foundation

Ocean Prayer

God, with all your wisdom, please bless all humans
and animals on land and in the sea, large and small,
the blue whales to the tiny minnows, please help us protect all
life on our ocean planet now and forever....

CONSERVATION
ORGANIZATIONS

American Oceans Campaign
725 Arizona Avenue
Suite 102
Santa Monica, CA 90401

Defenders of Wildlife
1244 19th Street N.W.
Washington, D.C. 20036

The Humane Society
 of the United States
2100 L Street, N.W.
Washingtion, D.C. 20036

National Geographic
Post Office Box 2895
Wahingtion, D.C. 20077-9960

National Audubon Society
700 Broadway
New York, NY 10003

American Society for the
 Prevention of Cruelty
 to Animals
441 E. 92nd Street
New York, NY 10128

Cousteau Society
930 West 21st Street
Norfolk, VA 23517

Greenpeace International
Keizersgracht 176
1016 DW Amsterdam
The Netherlands

Center for Environmental
 Education
624 9th Street N.W.
Washington, D.C. 20001

Greenpeace
Building E, Fort Mason
San Francisco, CA 94723

National Wildlife Federation
8925 Leesburg Pike
Vienna, VA 22184

Sierra Club
730 Polk Street
San Francisco, CA 94109

The Wilderness Society
900 17th Street N.W.
Washington, D.C. 20006

World Wildlife Fund
1601 Connecticut Ave. N.W.
Washington, D.C. 20009

Save the Whales, Inc.
1426 Main Street
Unit E
Post Office Box 2397
Venice, CA 90291

Dolphin Research Center
Post Office Box 2875
Marathon Shores, FL 33052

Mote Marine Laboratory
1600 Thompson Parkway
Sarasota, FL 34236

Surf Rider Foundation
122 S. El Camino Real #67
San Clemente, CA 92672

Wyland Foundation
Post Office Box 1839
Laguna Beach, CA 92651

wyland.com
make an impression

DIVE INTO THE

Order any one of these gorgeous coffee-table books and visit the sea through an environmental visionary, Wyland.

The Undersea World of Wyland
Foreword by Dr. Sylvia A. Earle
$39.95

This beautiful hardcover book takes you on a trip into Wyland's fine art world with over 160 pages of some of the artist's most unique original paintings. Includes twenty years of Wyland's best oil paintings and watercolors.

Wyland: The Whaling Walls
Introduction by Dr. Roger Payne
$39.95

Tour Wyland's world-renowned Whaling Wall murals through this lovely hardcover coffee-table book and learn why the artist has to paint life-size. Amazing full-color images of the artist, landmark walls, original paintings and sculpture. A must for ocean lovers.

The Art of Wyland
Introduction by Robert Bateman
$39.95

First in the series of Wyland's hardcover coffee-table books, *The Art of Wyland* shares the artist's earliest beginnings, showcasing his best paintings, and extraordinary mega-wall murals. The best of Wyland marine-life art.

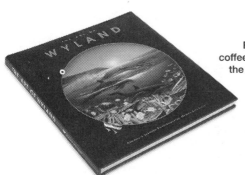

ORDER ONLINE AT WWW.WYLAND.COM

WORLD OF WYLAND

Wyland's collection of videos are a beautiful visual of the artist at work, be it in his studio, diving to study his favorite art subjects or simply creating one of his enormous Whaling Wall murals. Order your video today to have fun with this amazing artist.

Wyland's Ocean Planet
The Quest to Paint 100 Whaling Walls
Hosted by famed movie star Pierce Brosnan
$19.95

This fantastic show displays Wyland's famed Whaling Wall murals and his diving expeditions to study his favorite subjects. With life-size portraits of grays, blues, humpbacks and orcas, Wyland paints his story around the world.

The Art of Wyland
The World's Premier Environmental Marine Life Artist
Hosted by Lloyd Bridges
$19.95

The Art of Wyland allows you to peek into Wyland's private studio to see for yourself how this "Marine Michelangelo" is able to capture his favorite subjects, whales, dolphins and other marine-life, in paintings, sculpture and lifesize ocean murals.

Whaling Wall XXXI
Grey Whale Migration
Narrated by Leonard Nimoy
$19.95

This video story reveals what it takes to actually make a Whaling Wall mural happen in the community of Redondo Beach. Two football fields wide and ten stories tall, this spectacular landmark mural has brought a community together with an awareness and respect of our oceans and the marine life there in.

OR BY PHONE AT 1-800-WYLAND-0